Forever Frida

A Celebration of the Life, Art, Loves,
Words, and Style of Frida Kahlo

KATHY CANO-MURILLO

Adams Media

New York London Toronto Sydney New Delhi

Dedication

*This book is dedicated to all the people who are inspired by
Frida Kahlo's creativity and passion. May we all unite to become
a force of beauty, truth, love, and strength in this world.*

And to Frida.

*Muchas gracias, hermana. May you continue to rest in power,
and most of all peace.*

Adams Media
An Imprint of Simon & Schuster, Inc.
100 Technology Center Drive
Stoughton, Massachusetts 02072

Copyright © 2019 by Simon & Schuster, Inc.

All rights reserved, including the right to reproduce
this book or portions thereof in any form what-
soever. For information address Adams Media
Subsidiary Rights Department, 1230 Avenue of the
Americas, New York, NY 10020.

First Adams Media hardcover edition
July 2019

ADAMS MEDIA and colophon are trademarks of
Simon & Schuster.

For information about special discounts for bulk
purchases, please contact Simon & Schuster
Special Sales at 1-866-506-1949 or business@
simonandschuster.com.

The Simon & Schuster Speakers Bureau can bring
authors to your live event. For more information
or to book an event contact the Simon & Schuster
Speakers Bureau at 1-866-248-3049 or visit our
website at www.simonspeakers.com.

Interior design by Sylvia McArdle
Interior images by Kathy Cano-Murillo and
© Getty Images, Wikimedia.org

Manufactured in China

10 9 8 7 6 5 4

Library of Congress Cataloging-in-Publication Data
Names: Cano-Murillo, Kathy, author.
Title: Forever Frida / Kathy Cano-Murillo.
Description: Avon, Massachusetts: Adams Media,
2019.
Includes bibliographical references.
Identifiers: LCCN 2019006901 | ISBN
9781507210116 (hc) | ISBN 9781507210123
(ebook)
Subjects: LCSH: Kahlo, Frida. | Kahlo, Frida--
Miscellanea.
Classification: LCC ND259.K33 C36 2019 | DDC
759.972--dc23
LC record available at https://lccn.loc
.gov/2019006901

ISBN 978-1-5072-1011-6
ISBN 978-1-5072-1012-3 (ebook)

Many of the designations used by manufacturers
and sellers to distinguish their products are claimed
as trademarks. Where those designations appear
in this book and Simon & Schuster, Inc., was aware
of a trademark claim, the designations have been
printed with initial capital letters.

Acknowledgments

How does one truly capture everything about someone as complex as Frida Kahlo? As I worked on these pages, inhaled the air in Frida's bedroom at La Casa Azul, strolled the same streets she did in Coyoacán—I asked her for her blessing.

The mainstream has made her an icon of mass consumerism and pop culture, a shero for many walks of life. I learned she was a woman with hopes, dreams, ambitions, and insecurities, just like so many of us. Her legacy defies labels. Frida didn't set out to change the world or be a poster girl for any cause. She wanted to give and receive love. When life's tragedies attempted to knock her down, she fought back with her art, intellect, and sense of humor.

Frida still ignites a fire inside her admirers—and even her critics, which I'm sure would please her. For me, Frida represents being flawed, fearless, and fabulous.

Thank you to my editor, Cate Prato, and the team at Adams Media for this epic opportunity! Thank you to my husband, Patrick, for all his love and support; my amigas, The Phoenix Fridas; and Rose Mendoza of Dulce Vida Travel. Mil gracias to Omar Tadeo of Joyería MATL for all the wonderful stories about Frida and Diego, and to Janet Cantley of the Heard Museum for the resources. And most of all, thank you to all the Frida lovers out there—I hope you enjoy this book!

Introduction

Lover. Painter. Fashionista. Rebel.
Mother to all living creatures.
Enhancer of life. Embracer of death.

Above all, Frida Kahlo was a visual storyteller. Her language of resiliency transcended words and phrases. She relayed her darkest thoughts and most painful experiences with the strokes of a paintbrush, journal sketches, and drawings. Childhood polio, schoolyard bullying, physical disabilities, love affairs, a cheating husband, strong political views, and most of all, a passion for knowledge, added up to a vibrant life documented in artful mastery.

During her forty-seven years on earth, Frida enamored most and frightened more than a few. She endured days of both beauty and agony and didn't hold back from sharing every incident.

She embellished her reality the same way she did her oil paintings. She is the embodiment of love and the healing powers of self-expression.

Love for Mexico.

Love for mankind.

Love for nature.

Love for her body and soul.

Love for independent thinking.

Love for Diego.

This book is a love letter to Frida. Hear her voice in the carefully selected quotes. Feel her spirit in the entries about her life. This is a celebration of all her moments, big and small, that made an impact on the world.

Whether you are a man, woman, artist, pop culture aficionado, or fan of Mexican style, may you find joy, love, beauty, and spirit within these covers.

Viva Frida!

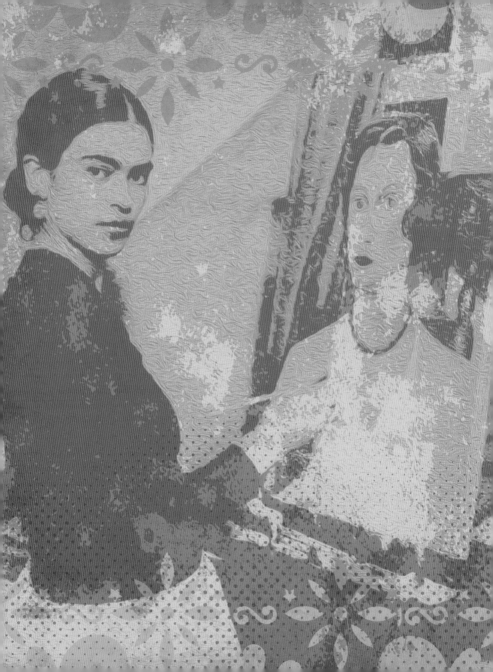

"I paint my own reality. The only thing I know is that I paint because I need to, and I paint whatever passes through my head without any other consideration."

*F*rida Kahlo entered the world on July 6, 1907, as Magdalena Carmen Frieda Kahlo y Calderón. She was born inside her parents' home, La Casa Azul, in Coyoacán, Mexico, and died there on July 13, 1954. Little did her father, Guillermo Kahlo, and her mother, Matilde Calderón y Gonzalez, know that Frida would trigger an artistic revolution for generations to come.

La Casa Azul.

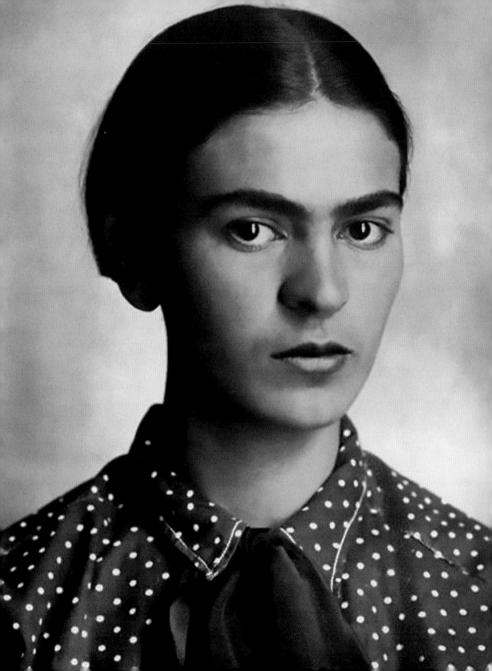

Frida was introduced to physical ailments early in her life. As a child she often assisted her father on his extensive photo shoots, not knowing he suffered from epilepsy. That is, until she witnessed his seizures, which became daily occurrences. Although young and frightened, she had no choice but to come to Guillermo's aid, as well as keep a close eye on his photo equipment so it would not be stolen.

Portrait by Guillermo Kahlo, 1926.

*E*ven before Frida's tumultuous relationship with Diego Rivera, she was well versed in romantic scandals. On the night his first wife died giving birth to his child, Guillermo Kahlo proposed to Matilde Calderón, a woman he worked with at a jewelry store in Mexico. She accepted, even though she nursed a broken heart from the suicide of her former love. Once remarried, Kahlo sent his two children from his first marriage to be raised in a convent.

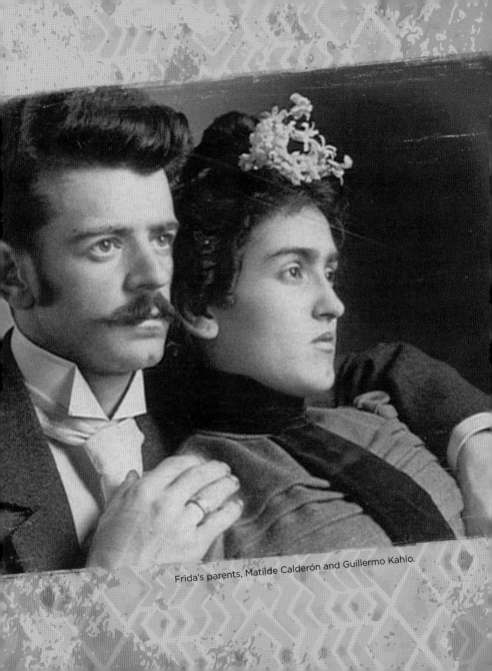

Frida's parents, Matilde Calderón and Guillermo Kahlo.

WHILE FRIDA IS CONSIDERED A SELF-TAUGHT ARTIST, HER FATHER HELPED SHAPE HER EARLY TALENT AND BUILT HER CONFIDENCE. HE ENROLLED HER IN BOXING, ROLLER SKATING, AND SOCCER TO HELP STRENGTHEN HER WEAK LEG, AND HE TAUGHT HER PHOTOGRAPHY. HE EVEN PUT HER TO WORK AT HIS FRIEND'S PRINTMAKING SHOP WHERE SHE REPLICATED PHOTOS BY HAND. SHE WENT ON TO BECOME A PAID APPRENTICE.

Art and creativity weren't Frida's only strengths. Frida earned one of thirty-five spots for women to attend Escuela Nacional Preparatoria, a prestigious Mexico City high school. She was known to be outspoken, and successful in her academics. While at school she joined the political group, Los Cachuchas, led by her future love, Alejandro Gómez Arias. She was one of two girls out of the seven rowdy members.

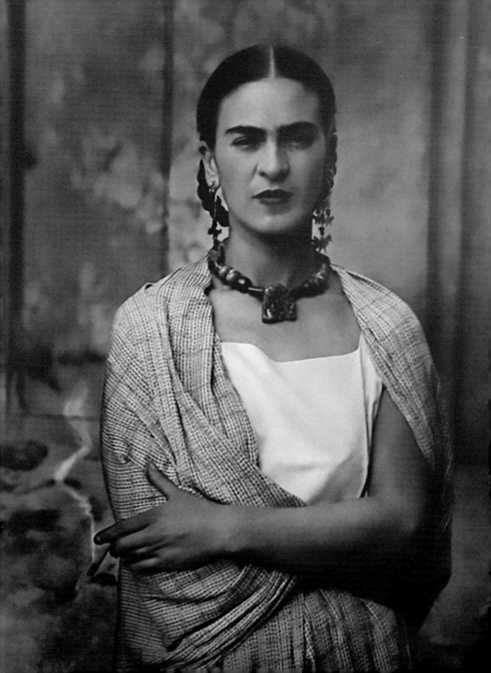

GUILLERMO KAHLO'S CREATIVITY INFLUENCED FRIDA FROM AN EARLY AGE UNTIL ADULTHOOD. AS A PROFESSIONAL PHOTOGRAPHER, HE DOCUMENTED MEXICAN ARCHITECTURE, INCLUDING CHURCHES, STREETS, AND LANDMARKS. ALSO KNOWN FOR TAKING HAUNTING PORTRAITS OF HIMSELF, AS WELL AS HIS FAMILY, HIS STYLE CAN BE NOTICED IN FRIDA'S PAINTED SELF-PORTRAITS.

Portrait by Guillermo Kahlo, 1932.

All through her life Frida fought for a world free from oppression. During the Mexican Revolution she was only five years old, and heard the gunshots of the Zapatistas— the followers of revolutionary leader Emiliano Zapata—outside the windows of La Casa Azul. Their chants of "Tierra y Libertad" (land and freedom) would go on to represent her political views.

ome September, Frida displayed her love for Mexican Independence Day by decorating with all things red, white, and green, the colors of the Mexican flag. From the ribbons in her hair to small toys and paper banners strewn throughout her home, she added an artistic, magical touch to every corner of her house.

\mathcal{F}rida always stood strong, even as a young girl dealing with bullies at school. They teased her about her awkward limp, calling her "peg leg." While she acted as though the insults didn't bother her, later in adulthood she wrote in her diary that they hurt her spirit and she often relied on her imaginary friend for comfort.

"I used to think
I was the strangest person in the
world but then I thought there are
so many people in the world, there
must be someone just like me who
feels bizarre and flawed in the same
ways I do. I would imagine her,
and imagine that she must be out
there thinking of me too. Well, I
hope that if you are out there and
read this and know that, yes, it's
true I'm here, and I'm just
as strange as you."

At eighteen years old, Frida excelled in medical school and was madly in love with a fellow student, the handsome Alejandro Gómez Arias. But one September afternoon her fate changed when the bus she and Alejandro were riding in collided with a trolley. Frida was thrown from the vehicle, and a steel handrail impaled her through one side of her pelvis and out from between her legs. Her clothes ripped away and she lay naked in the street, bleeding, covered only by gold powder that had spilled from the hands of another passenger. Before Alejandro had a chance to act, a man anchored his knee to Frida's body and ripped out the pole. Alejandro said Frida screamed so loud that he couldn't even hear the ambulance sirens.

Portrait by Guillermo Kahlo, 1932.

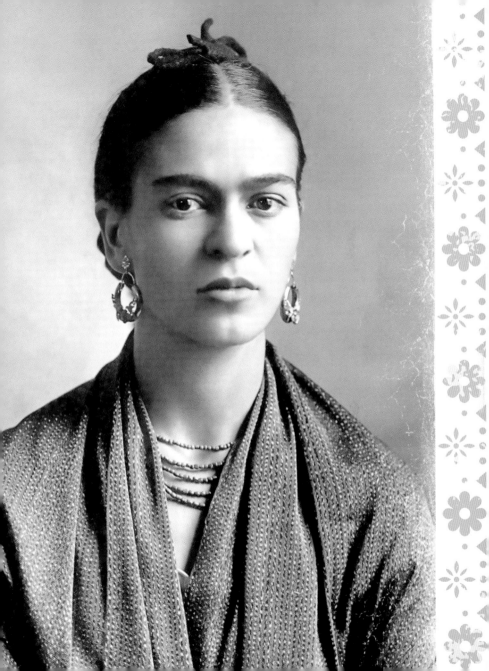

*F*rida's severe bus accident left her bedridden and lonely for months. Her injuries were massive and included three breaks in the lumbar region of her spinal column, a broken collarbone, two broken ribs, eleven fractures in her right leg, a crushed right foot, and three breaks in her pelvis. While she healed from her injuries she painted *Self-Portrait in a Velvet Dress* as a gift to Alejandro, as their relationship had become unsteady. Alejandro eventually moved to Europe, and Frida continued to paint her portraits.

"For many years my father had kept a box of oil paints and some paintbrushes in an old jar and a palette in the corner of his photographic studio....Being confined to a bed for so long, I finally took the opportunity to ask my father for it. Like a little boy whose toy is being taken away from him and given to a sick brother, he lent it to me. My mother asked a carpenter to make me an easel, if that's what you can call the special apparatus which could be fixed onto my bed, because the plaster cast didn't allow me to sit up. And so I started on my first picture, the portrait of a friend."

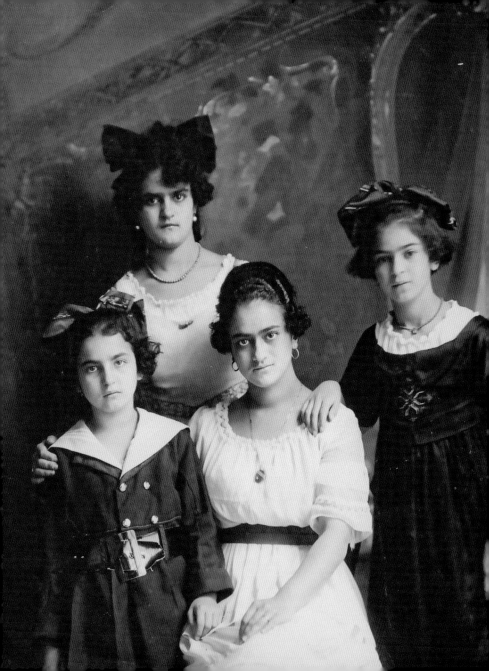

*W*hile not the happiest of unions, Frida's parents went on to have five children: a boy who died in infancy and four girls: Matilde, Adriana, Frida, and Cristina. Frida seems to include her family members and grandparents in an unfinished family portrait that she worked on from 1940 until her death in 1954. The piece also includes two faceless females, what appears to be a young boy, and a fetus. Many wonder if the children represent her half sisters from her father's first marriage or her cousins, and if the fetus is one of her unborn children or possibly her brother.

Cristina, Adriana, Matilde, and Frida Kahlo, 1919.

At fifteen years old, Frida was studying at San Ildefonso College at the same time Diego Rivera, a revered Mexican painter, was working on the mural *Creation* in the campus auditorium. Frida often taunted him, stole from his lunch, and called him "toad face" and "panzón" (potbellied). She spied on him when he took breaks from painting and giggled as he made love to his second wife, Lupe, and, when she wasn't around, his mistress.

"I suffered two great accidents in my life. One in which a streetcar knocked me down....The other accident is Diego. Diego was the worst."

"I love you more than my own skin and even though you don't love me the same way, you love me anyways, don't you? And if you don't, I'll always have hope that you do, and I'm satisfied with that. Love me a little. I adore you."

ONCE HEALED FROM HER TROLLEY ACCIDENT

AND OUT OF SCHOOL, FRIDA APPROACHED DIEGO

AS HE WORKED ON A MURAL. SHE ADMIRED

THE ARTIST AND ASKED HIM TO CRITIQUE HER

NEWFOUND HOBBY OF PAINTING PORTRAITS. HE

LIKED THEM—AND HER—SO MUCH THAT HE BEGAN

TO VISIT HER AT LA CASA AZUL EVERY SUNDAY

UNTIL HE ASKED HER TO MARRY HIM.

This is like a wedding between "an elephant and a dove," said Matilde Calderón when her petite twenty-two-year-old daughter, Frida, married the towering and heavyset forty-two-year-old Diego. Frida's parents knew of his notorious reputation with women, and ultimately, her mother did not attend the wedding, but her father did.

Diego's quote inscribed on a wall in La Casa Azul. It says "To the little girl Fridita Kahlo the marvelous. July 7 1956 After two years ashes live in my heart."

A LA NIÑA FRIDITA
KAHLO LA MARAVI
LLOSA. EL 7 DE JULIO
DE 1956 A LOS DOS
AÑOS QUE DUERME
EN CENIZAS, VIVA
EN MI CORAZON

Diego Rivera

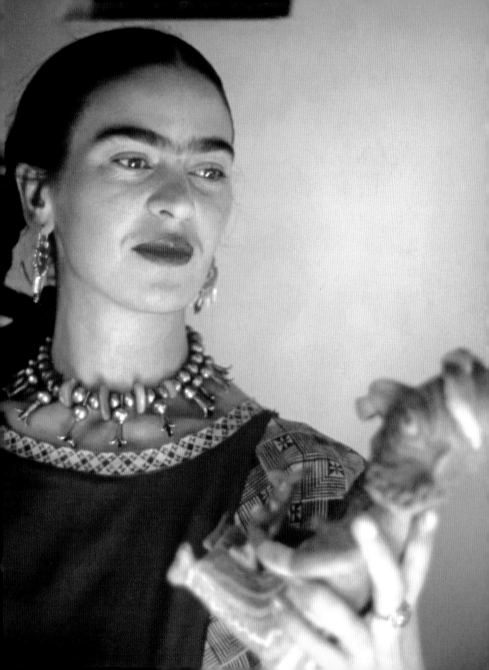

*F*rida's taste in necklaces, earrings, rings, and bracelets was eclectic and dramatic. She wore the Baroque-inspired silver jewelry of artist Matilde Poulat of Mexico City daily. The pieces took hours of intimate construction to create and were set with chunky stones of turquoise and coral. Her other jewelry ranged from irregular pre-Columbian stones to pieces she bought at New York City dime stores, and even included objects believed to have been excavated from Mayan burial sites. Admirers of her time recalled the sound of her stepping into the room because she sounded like "a cathedral gone mad with all the bells jangling." But while Frida's jewelry collection was quite extensive and elaborate, she freely shared, traded, and gifted her pieces to friends and family.

Frida, c. 1940.

FRIDA LOVED TO COOK AND SERVE TRADITIONAL MEXICAN MEALS TO FRIENDS AND FAMILY; HOWEVER, ACCORDING TO HER NIECE, ISOLDA, SHE ALSO SAVORED SPAGHETTI. ANOTHER FAVORITE OF FRIDA'S WAS JICAMA DOUSED WITH HOT, HOT CHILI AND A SQUEEZE OF LEMON.

*F*rida's love of Mexico extended to the drinks she served at dinner. She often created three homemade flavored waters—lime, white rice, and hibiscus flower—that represented the colors of the Mexican flag. She served these drinks in blown glass, blue-rimmed goblets.

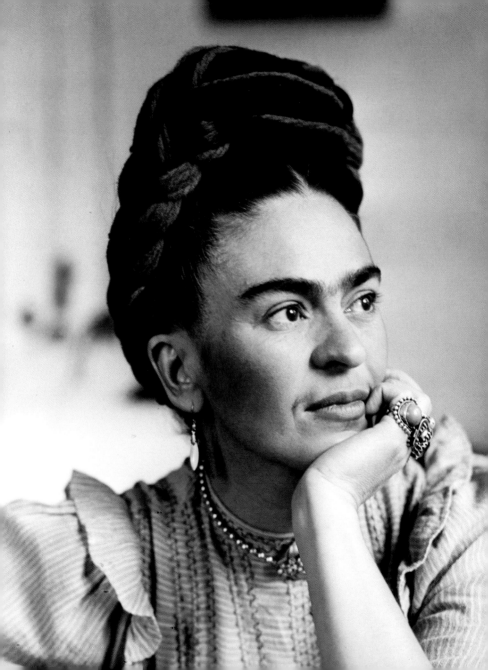

"To paint is the most terrific thing that there is, but to do it well is very difficult."

Frida, 1952.

Frida grew a variety of flowers in her garden at La Casa Azul. She cut the blooms daily to wear on her head, as well as for use in her home and on her dining table. The roses, bougainvillea, and elephant ears she wore in her hair weren't only a fashion statement; they also signified her love of nature.

———————

Frida's natural beauty shines through in photos as well as her self-portraits. While she cherished excessive jewelry, headpieces, and clothing, she wasn't a fan of heavy makeup. She only used a bit of blush on her cheeks, red nail polish, and a black eyebrow pencil. She did adore her red lipstick, which she used to add kisses to her letters to loved ones.

"I love you with
all my loves. I'll give you the
forest with a little house in it.
With all the good things there
are in my construction, you'll
live joyfully—I want you
to live joyfully."

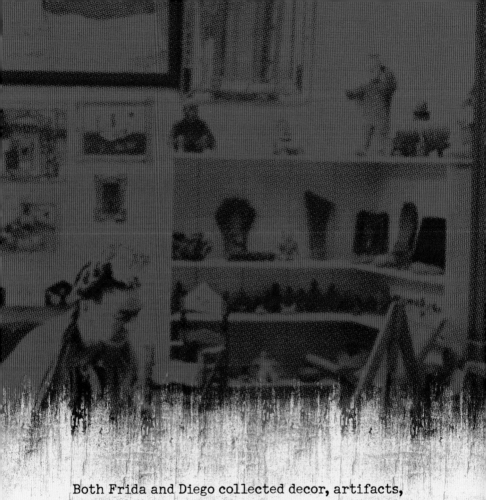

Both Frida and Diego collected decor, artifacts, and relics from around the world for their home collection. Dolls, figurines, statues, toys, dishes, sculptures, carvings, and more adorned their houses with color, culture, and history.

AMONG FRIDA'S FAVORITE PETS WERE HER SPIDER MONKEYS, FULANG-CHANG AND CAIMITO DE GUAYABAL. CAIMITO PROVED TO BE EXTREMELY PROTECTIVE OF DIEGO. WHENEVER FRIDA APPROACHED HER HUSBAND, CAIMITO GROWLED, SNARLED, AND ATTEMPTED TO BITE. ONE DAY CAIMITO CAME AFTER FRIDA WITH A WOODEN STICK, AND FRIDA'S LITTLE NIECE, ISOLDA, JUMPED TO HER DEFENSE. DIEGO LEFT THE NEXT DAY WITH CAIMITO AND RETURNED WITHOUT HER.

Frida and one of her pet monkeys, 1944.

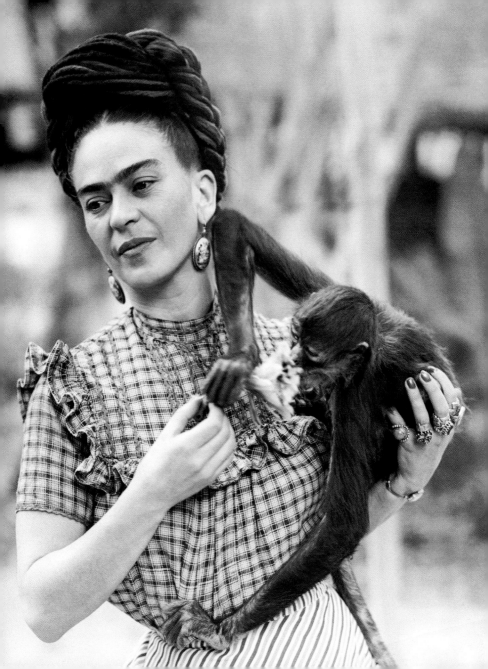

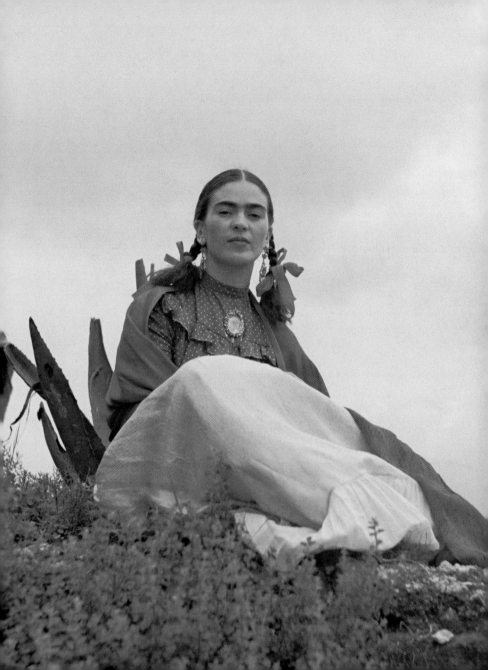

Throughout her life, Frida showcased her bold sense of fashion. She wore elaborately embellished Tehuana garments, most notably the long A-line skirts adorned with floral embroidery, and huipils—heavy woven tops. There were several reasons she flaunted this fashion: Diego adored the indigenous look, and she wanted to honor and show off her Mexican culture. The skirts' long length, along with layers of socks, also hid her shorter right leg, the result of childhood polio and the trolley accident she endured during her teen years. After her leg was amputated when she was an adult, she donned a prosthetic leg outfitted with a bright red boot.

Frida Kahlo, *Vogue* photo shoot, 1937.

Frida's love of Mexico took center stage for much of her life, but her ancestry is a mixture of German from her father and Mexican, Spanish, and Mexican indigenous from her mother. Frida found ways to weave all of these cultures into her life and work.

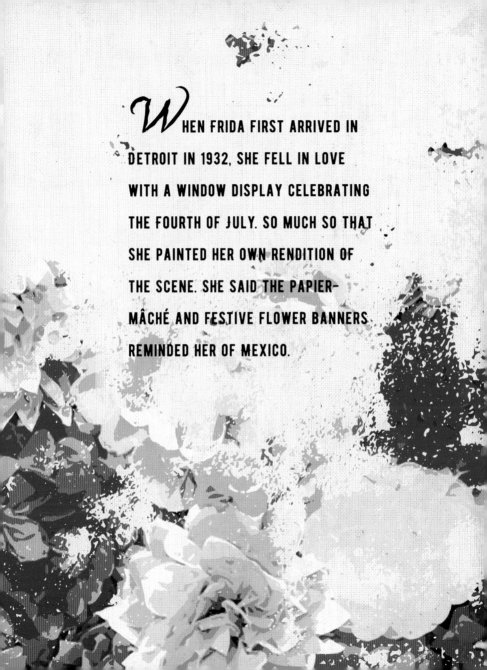

When Frida first arrived in Detroit in 1932, she fell in love with a window display celebrating the Fourth of July. So much so that she painted her own rendition of the scene. She said the papier-mâché and festive flower banners reminded her of Mexico.

FRIDA MAY HAVE FELT TORMENTED INTERNALLY,
BUT ON THE OUTSIDE, SHE EXUDED CONFIDENCE.
WITH FLOWERS TOWERING IN HER HAIR, DONNING
HEAVY STONE NECKLACES, SHE WRAPPED
HERSELF IN A BRIGHT SHAWL CALLED A REBOZO
AND LAYERED TRADITIONAL TEHUANA CLOTHING
UNDERNEATH. FRIDA STROLLED ABOUT THE STREETS
IN COYOACÁN, OFTEN HECKLED BY THE LOCALS—
THEY CALLED HER "THE CLOWN." FRIDA DIDN'T CARE;
IT ONLY EMPOWERED HER MORE.

Tehuana garments on display at La Casa Azul.

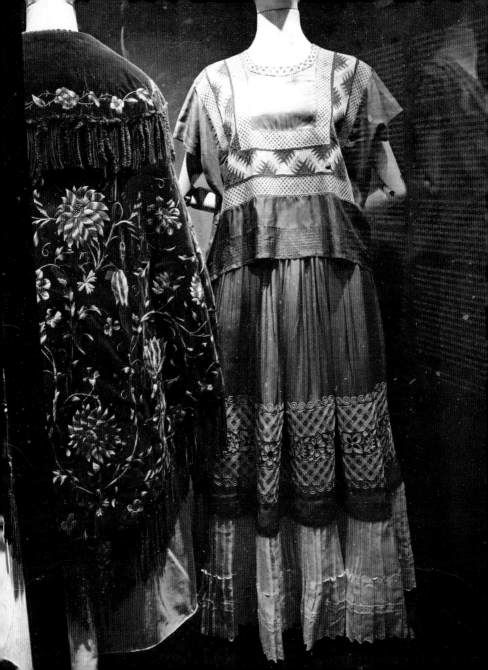

"You have to be honest; we women cannot live without pain."

*F*rida's relationship with her mother, Matilde, was not as warm as the one she had with her father. In an interview, Frida once described her as "kind, active, and intelligent, but also calculating, cruel, and fanatically religious." Even so, the two shared a strong bond, proven by the many loving and supportive letters they exchanged throughout the years. Frida was living in Detroit when she received a telegram about her mother's breast cancer and gallstones. The artist immediately returned home to Coyoacán to be by her mother's side when she passed.

*F*rida's life and work constantly evolved, not always by her choice. During her and Diego's four-year stay in Detroit, she suffered her second miscarriage. Devastated and depressed, she was encouraged by Diego to paint her life's experiences. *Henry Ford Hospital* unleashed a raw, graphic look inside Frida's mind and tortured soul. The painting showed her on the bed, bloodied and surrounded by imagery related to the baby she lost. It was her first oil on metal painting, and measured only 12¼" by 15½".

\mathcal{A} strong source of inspiration
for Frida's artwork came from ex-votos.
Dating back to the sixteenth century,
these small paintings on metal were
created by people offering gratitude to
the Catholic Church for a miracle or for a
favor. They usually include a picture of
a saint and a written description. Frida's
collection exceeded 400 ex-votos, some
still on display at La Casa Azul.

The earliest Frida creation dates back to 1912. Measuring approximately 4" by 7", it's a framed cross-stitch piece titled *The Little House* and is now part of a private collection in Mexico City. Five-year-old Frida made it when her mother encouraged all her daughters to make the prettiest sewn crafts they could, even once offering a reward. Frida won, but later admitted she cheated by paying a schoolmate to do the work.

"I was born a bitch, I was born a painter."

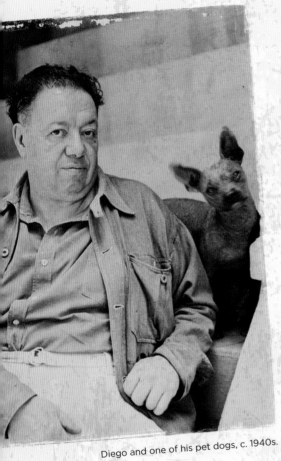

Diego and one of his pet dogs, c. 1940s.

A doctor once told Diego Rivera he was incapable of monogamy. Less than a year into the Riveras' marriage, Diego cheated, and never stopped, even having an ongoing affair with Frida's sister and confidante, Cristina. By the end of 1939, Diego divorced Frida after falling in love with actress María Félix.

"I cannot speak of Diego as my husband because that term, when applied to him, is an absurdity. He never has been, nor will he ever be, anybody's husband."

"I am broken. But I am happy to be alive as long as I can paint."

A close-up of Frida's *The Bride Frightened at Seeing Life Opened*, 1943.

IN 1939, SOON AFTER HER DIVORCE FROM DIEGO, FRIDA PAINTED *THE TWO FRIDAS*. THE IMAGE SHOWED OPPOSITE VERSIONS OF FRIDA, AND REPRESENTED HER WOUNDED HEART AND HER ANGUISH AT HER AND DIEGO'S FAILED LOVE. FRIDA CLAIMED THE PIECE WAS ALSO INSPIRED BY HER IMAGINARY CHILDHOOD FRIEND WHO ALWAYS OFFERED SUPPORT IN TIMES OF SUFFERING.

Frida standing next to
The Two Fridas, 1939.

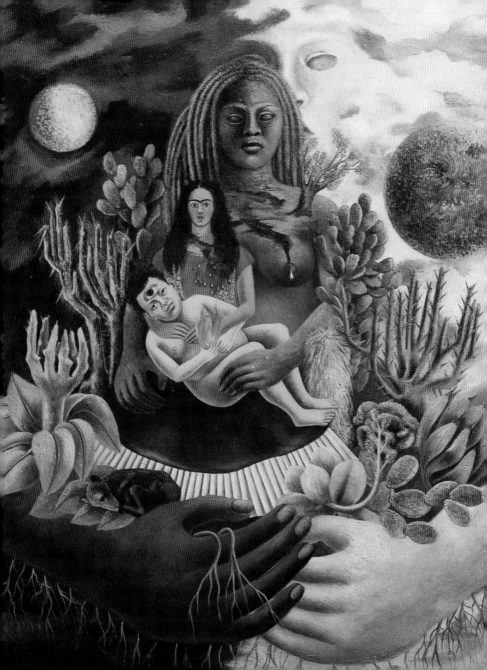

"*Diego was everything; my child, my lover, my universe.*"

The Love Embrace of the Universe, the Earth (Mexico), Myself, Diego, and Señor Xolotl, 1949.

\mathcal{F}rida set two clocks in her kitchen. One shows the time Diego cheated on her with her sister, Cristina. The other shows the hour she and Diego remarried. Today, the clocks are on display in La Casa Azul.

Frida's "divorce clocks" at La Casa Azul.

"Tree of hope, stand firm."

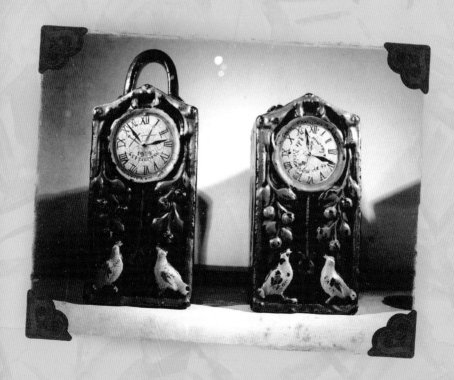

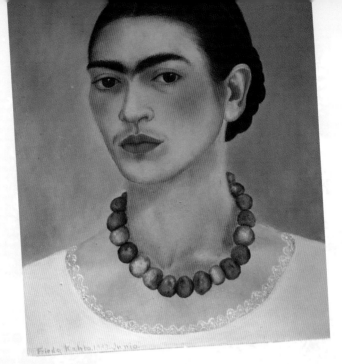

Self-Portrait with Necklace, 1933.

Over her bed. In her studio. Next to her
dressing table. Even on her patio wall.
Frida surrounded herself with mirrors.
These reflected a dual concept—for vanity's
sake, but mostly so Frida would be able to
see herself to work on her self-portraits.

"The mirror!
The executioner
of my days!"

Frida often ventured away from her usual surroundings to find artistic inspiration. Some days, she and Diego loaded their giant easels and art supplies in the back of his rickety truck—which was peppered with holes he patched with wood panels—and hired a chauffeur to drive them from town to town so they could sketch.

Frida and Diego, 1932.

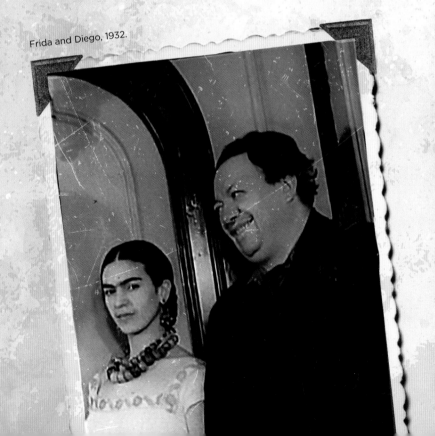

"There is nothing more precious than laughter."

*A*RTISTS AND CRITICS OF FRIDA'S DAY LABELED HER AS A SURREALIST. ANDRÉ BRETON, LEADER OF THE SURREALISM MOVEMENT, SAID: "THE ART OF FRIDA KAHLO IS LIKE A RIBBON AROUND A BOMB." FRIDA RESISTED. SHE SAID SHE ONLY PAINTED WHAT SHE KNEW BEST: HERSELF. DIEGO AGREED; HE CONSIDERED HER A REALIST.

"I don't know
if my paintings are
Surrealist or not, but
what I am sure of is
that they are the most
honest expression of
my being."

*N*o love matched what Frida felt for Diego, although she did fall in deep, meaningful love with a few other men in her lifetime. Among them was Alejandro Gómez Arias, whom she met while in prep school. Another was Hungarian photographer Nickolas Muray, who was best known for taking striking photos of Frida in bold colors. Their relationship lasted a decade. Nickolas adored her madly, but Frida ultimately returned to Diego.

"Nothing is absolute. Everything changes, everything moves, everything revolves, everything flies and goes away."

Frida doll.

*M*any believe Frida graced the cover of *Vogue Paris* in 1939. While this didn't occur, she did appear in a feature article in American *Vogue* in 1937 and, in 2012, the iconic green floral background image of her taken by Nickolas Muray was featured in *Vogue Mexico.*

"Give me hope, make me dream, will to live and don't forget me."

An ofrenda for Frida.

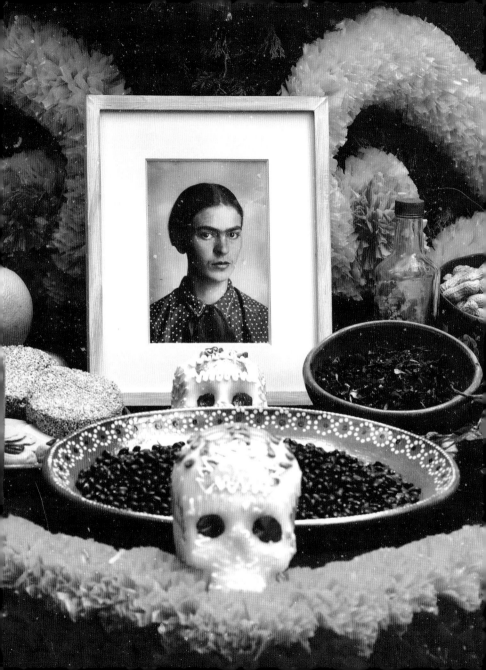

AN AVID SMOKER, FRIDA LOVED LUCKY AND BELMONT BRANDS. SO MUCH SO, THAT WHEN CURATORS DISCOVERED A TRUNK HIDDEN IN LA CASA AZUL, THEY OPENED IT TO FIND THE CONTENTS PERMEATED WITH HER PERFUME AND CIGARETTE SMOKE.

Frida's perfume smelled of honey and roses, thanks to her love of Shocking by Italian fashion designer Elsa Schiaparelli. Shalimar by Jacques Guerlain also ranked high as a favorite.

"I'd like to paint you, but there are no colors, because there are so many, in my confusion, the tangible form of my great love."

Frida, 1950.

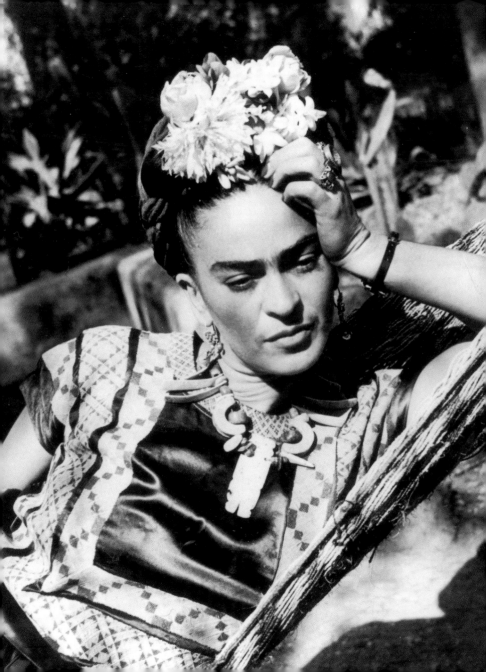

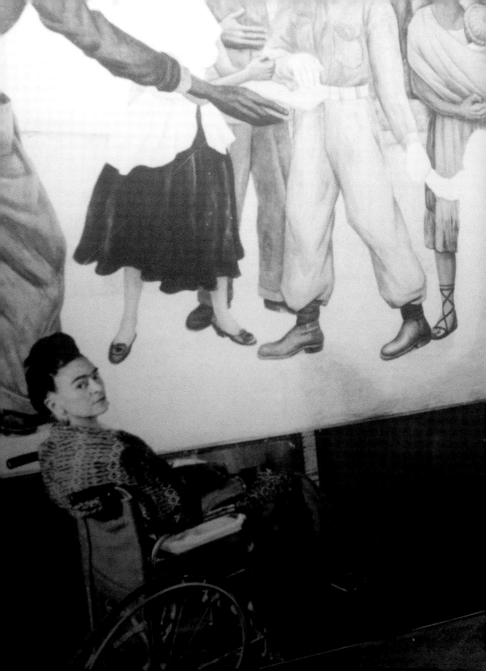

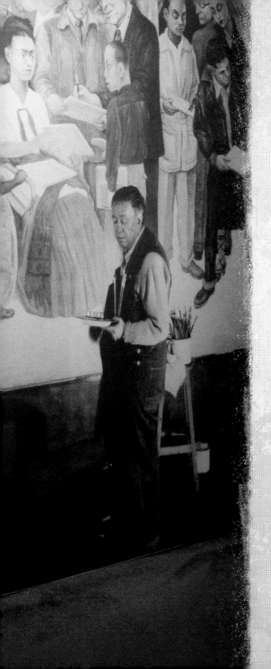

In 1951, Dr. Juan Farill performed seven spine surgeries on Frida. Confined to a wheelchair, cared for by nurses, and consuming large doses of painkillers, she still managed to complete several paintings, including two deeply meaningful works. One was *Portrait of My Father*, honoring her dad, Guillermo Kahlo. The other was *Self-Portrait with the Portrait of Dr. Farill*. Even confined due to her health, Frida still accompanied Diego to his work sites.

Frida watches Diego paint, c. 1940s.

"Mankind owns its destiny, and its destiny is the earth. We are destroying it until we have no destiny."

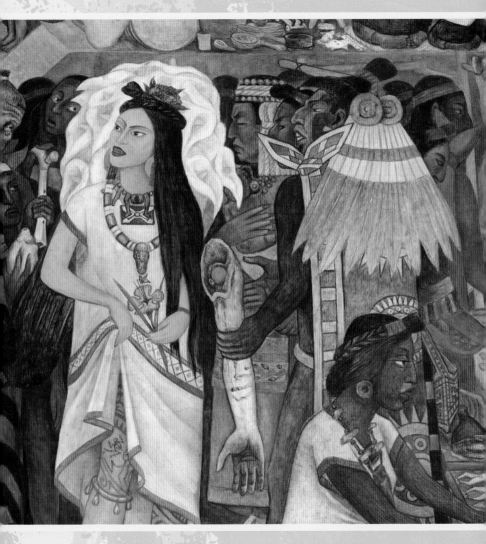

One of Diego's many murals in Mexico.

*F*rida's niece, Isolda, recalls the time she visited her aunt in the hospital after one of her many surgeries. She saw the corrective steel bands that cradled the artist's head in an awkward and painful position. Rather than rest, Frida positioned an easel on her lap and painted—and even sang one of her favorite songs.

MUSIC PLAYED A GRACEFUL ROLE IN FRIDA'S PRODUCTIVITY. SOME OF HER FAVORITE SONGS TO PAINT TO INCLUDED "CIELITO LINDO," "EL VENADITO," AND "LA LLORONA."

"Perhaps it is expected that I should lament about how I have suffered living with a man like Diego. But I do not think that the banks of a river suffer because they let the river flow, nor does the earth suffer because of the rains, nor does the atom suffer for letting its energy escape. To my way of thinking, everything has its natural compensation."

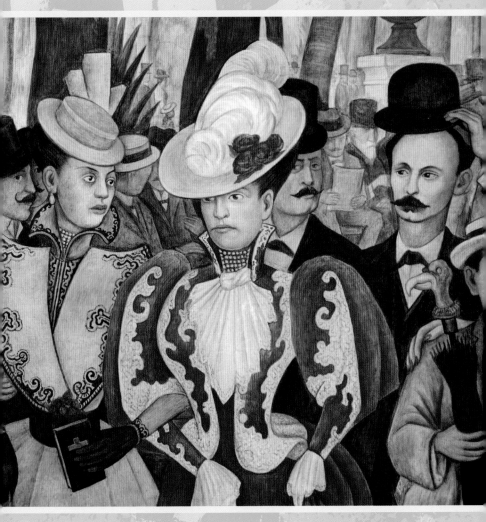

A close-up of Diego Rivera's *Dream of a Sunday Afternoon in Alameda Central Park*, featuring Frida, 1946–1947.

In the cold month of January 1939, Frida, then thirty-two, packed her suitcases. She left behind La Casa Azul, Diego, and Mexico to travel alone to Paris for a group show organized by André Breton, a leader of the surrealism movement. Due to a kidney infection, Frida entered a Paris hospital but healed in time to sail to the United States for her solo exhibit at the Julien Levy Gallery, her only solo show in New York City. Frida returned home in April. Despite her illness and pain, the experience was monumental in that she was recognized for her own talents and not for being Diego's wife.

*F*rida and Diego remarried on his fifty-fourth birthday, December 8, 1940, in San Francisco. In their first marriage, Frida worked diligently to be a perfect wife. The second time, she evolved into a stronger, more independent woman—and an established artist. The couple agreed to be more companions than lovers. She took over the household finances, left at night to socialize with friends, and had numerous affairs.

"The most interesting thing about the so-called lies of Diego is that, sooner or later, the ones involved in the imaginary tale get angry, not because of the lies, but because of the truth contained in the lies, which always comes forth."

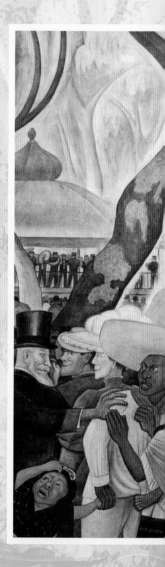

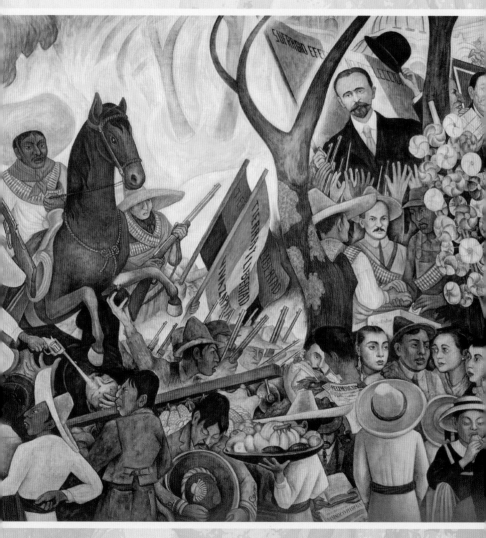

A close-up of Diego Rivera's *Dream of a Sunday Afternoon in Alameda Central Park*, featuring Frida, 1946–1947.

*I*n 1943, Frida became a teacher at La Esmeralda National School of Painting, Sculpture, and Printmaking in Coyoacán. Frida's students adored her so much that some even formed a clique called Los Fridos. When she became too ill to travel to the campus, Los Fridos visited La Casa Azul for their lessons. Frida taught her students to see beyond the obvious colors of their subjects and notice the colorful tones cast by lights and shadows. She also asked them to use everyday city life, pop culture, and current events as subject matter for their paintings, sketches, and even murals.

"I don't want you to think like I do. I just want you to think."

*L*avish roses were a daily fashion and decorating accessory for Frida, which is why she now has an official floribunda, a hybrid garden rose, named in her honor. The Frida Kahlo rose is bold and rounded with bright stripes of red and yellow that become brighter with age. The blooms are one of a kind, just like Frida.

Flowers at a La Casa Azul ofrenda in honor of Frida.

"I paint flowers so they will not die."

"I'll try out the pencils
sharpened to the point of
infinity, which always
sees ahead:

GREEN—good warm light

MAGENTA—Aztec. old TLAPALI blood of prickly pear,
the brightest and oldest

BROWN—color of mole, of leaves becoming earth

YELLOW—madness sickness fear part of the sun and of happiness

BLUE—electricity and purity love

BLACK—nothing is black—really nothing

OLIVE—leaves, sadness, science, the whole of Germany
is this color

YELLOW—more madness and mystery all the ghosts wear clothes
of this color, or at least their underclothes

DARK BLUE—color of bad advertisements and of good business

BLUE—distance. Tenderness can also be this blue

RED—blood? Who knows!"

Self-Portrait with Monkey, 1938.

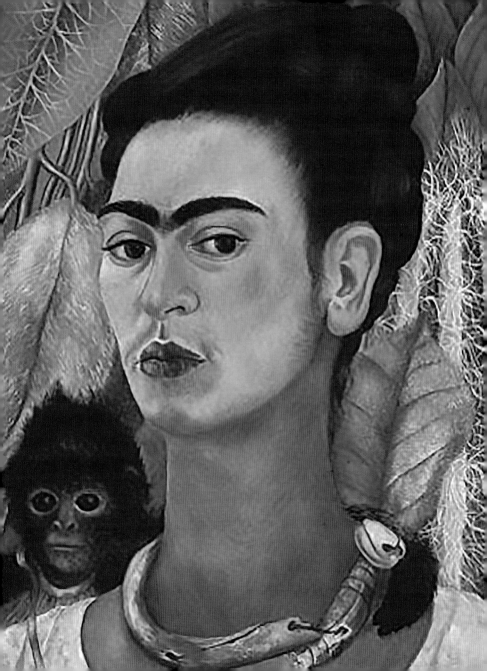

*F*rida included monkeys in eight of her paintings, where they appear to serve as her loyal protectors. Frida often incorporated Mexican mythology in her works, and in that world, monkeys represent fertility, lust, mischief, energy, knowledge, and a love of the arts. Some also believe she painted the monkeys as a tribute to Los Fridos, her art students. Others say they represent the children she couldn't have.

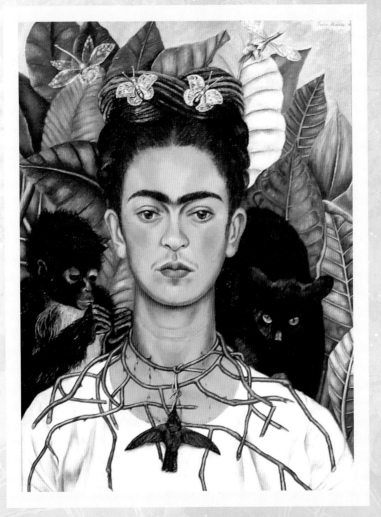

Self-Portrait with Thorn Necklace and Hummingbird, 1940.

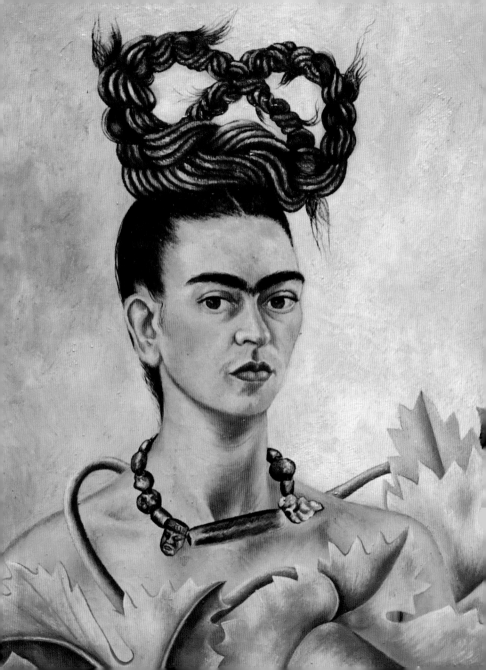

IN HER LIFETIME, FRIDA CREATED 143 ORIGINAL PAINTINGS, FIFTY-FIVE OF WHICH WERE SELF-PORTRAITS.

Self-Portrait with Braid, 1941.

IN THE 2002 FILM *Frida*, STARRING SALMA HAYEK, LEGENDARY RANCHERA SINGER CHAVELA VARGAS PERFORMS "LA LLORONA" TO TRANSLATE FRIDA'S PAIN AFTER DIEGO REQUESTS A DIVORCE. VARGAS HELD FRIDA CLOSE TO HER HEART. THE TWO SHARED AN INTIMATE FRIENDSHIP IN THE 1940S. CHAVELA, WHO PASSED AWAY IN 2012 AT AGE NINETY-THREE, OFTEN SANG TO FRIDA WHILE SHE PAINTED, AND CLAIMED THE TWO WERE ONCE LOVERS.

IN 1935, FRIDA BECAME ROMANTICALLY INVOLVED WITH JAPANESE-AMERICAN SCULPTOR AND ARCHITECT ISAMU NOGUCHI. HE VISITED MEXICO CITY FOR A COMMISSION AT THE MERCADO ABELARDO RODRÍGUEZ, AND WAS INTRODUCED TO FRIDA THROUGH DIEGO. THE TWO FELL MADLY IN LOVE AND ALMOST MOVED IN TOGETHER UNTIL DIEGO DISCOVERED THE AFFAIR. NOGUCHI GIFTED FRIDA A BEAUTIFUL BUTTERFLY COLLECTION, WHICH SHE HUNG UNDER THE CANOPY OF HER BED SO SHE COULD SEE IT EVERY DAY.

"I leave you my portrait so that you will have my presence all the days and nights that I am away from you."

Photos on display at La Casa Azul.

Frida treasured her long raven hair and used it in her paintings to relay her state of mind. After her divorce, she suffered from depression. Frida chopped off her locks and painted *Self-Portrait with Cropped Hair* in 1940; she also started *Self-Portrait as a Tehuana (Diego on My Mind)*. Three years later, remarried to Diego, she became financially independent with her art career and as a professor. She also created *Me and My Parrots*—in this piece, her hair is styled as an academic cap and her stance conveys self-confidence.

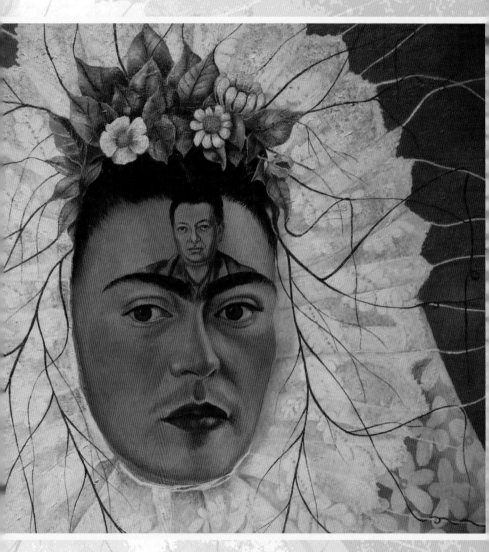

A close-up of *Self-Portrait as a Tehuana (Diego on My Mind)*, which Frida finished in 1943.

There were several turning points in Frida's career. Until 1932, she mostly painted portraits, but after the anguish of her second miscarriage, she entered a new era of graphic imagery and symbolism with *Henry Ford Hospital*, *My Birth*, *Self-Portrait on the Borderline Between Mexico and the United States*, and *My Dress Hangs There*. She made a clear choice to share the most intimate details of her pain. Collectors noticed. In 1938, actor Edward G. Robinson purchased four originals for $200 each, and the next year the Louvre in Paris purchased *The Frame*, its first acquisition from a twentieth-century Mexican artist.

FRIDA DIDN'T SELL MANY PAINTINGS IN HER LIFETIME, AND OFTEN GAVE THEM AWAY AS GIFTS. IN 2016, FRIDA'S *TWO NUDES IN A FOREST* SOLD FOR $8.005 MILLION AT A CHRISTIE'S AUCTION IN NEW YORK. CREATED IN 1939 AS A GIFT FOR ACTRESS DOLORES DEL RIO, IT HOLDS THE RECORD FOR THE HIGHEST SELLING PIECE OF ANY LATIN AMERICAN ARTIST AT AUCTION.

*F*RIDA ADORED ALL LIVING THINGS, ESPECIALLY ANIMALS. IN ADDITION TO MONKEYS, SHE OWNED MACAWS, PARAKEETS, SPARROWS, HENS, AND BONITO, THE AMAZON PARROT. SHE EVEN OWNED AN EAGLE, GERTRUDIS CACA BLANCA. FRIDA ALSO ADOPTED MR. XOLOTL—HER HAIRLESS MEXICAN DOG. THE BREED IS KNOWN AS XOLOITZCUINTLI AND TRACES BACK TO THE AZTECS; FRIDA LOVED THIS BREED.

Diego and Frida with their pet dog, c. 1940s.

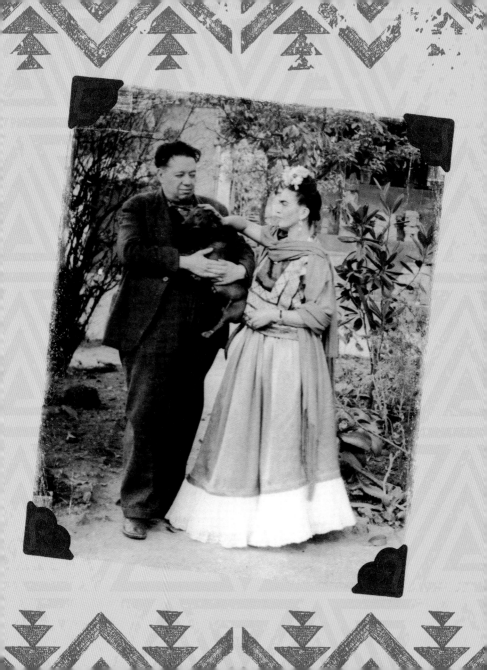

*F*rida had many versions of her name throughout her life. Born as Magdalena Carmen Frieda Kahlo y Calderón, she eventually removed the "e" from Frieda. Some say she did this to distance herself from her German heritage during the Second World War; others say she wanted the number of letters in her name to match Diego's so they would appear more balanced when written. During her first marriage to Diego, she signed some of her work Frida Rivera or Frida Kahlo de Rivera, but ultimately stayed with Frida Kahlo.

...supuesto y si lo ... la
mucho menos. Si
más quiero y por eso me atrevo a ...
...o con tanta tontería. Perdóneme y ...
conteste ésta carta cuénteme como ...
reciba de Diego y de mí, nuestro ...
... abrazo de

Frieda.

...l cree que me debo hacer la oper...
...iatamente le agradecería me pus...
...grama diciéndom... el asunto e...
...cado para no comprometerlo ...

One of Frida's many letters.

*F*rida never hesitated to put a twist on tradition. From donning a men's suit for a backyard family portrait to draping her broken body in gorgeous Tehuana regalia for nightlife in Paris, her outward persona was as brazen as her paintings, her love life, and her politics.

"Make love,
take a bath,
make love
again."

WHEN FRIDA'S SISTER, CRISTINA, DIVORCED HER HUSBAND, SHE MOVED INTO LA CASA AZUL WITH HER SON, ANTONIO, AND DAUGHTER, ISOLDA. FRIDA CHERISHED HER NIECE AND NEPHEW. WHEN LITTLE ISOLDA BUILT AN UNSAFE MAKESHIFT TREE HOUSE, FRIDA DISTRACTED HER BY ASSEMBLING A LITTLE STORE FOR HER NIECE TO MANAGE. THE TWO OFTEN WALKED TO THE MARKET TO BUY MERCHANDISE FOR ISOLDA TO SELL.

"It is strength to laugh and to abandon oneself, to be light."

\mathcal{D}iego and Frida lived in Detroit for a year as he worked on mural commissions, and then the couple moved to New York City. Frida longed for home, covering the walls of their hotel room with Mexican ads, posters, and art. However, Diego yearned to stay, resulting in many arguments between the two. But when money ran out, friends raised the funds for the Riveras' boat tickets back to Mexico.

WHILE FRIDA HAD MANY CRITICISMS OF AMERICAN CULTURE, SHE DID ENJOY A LIST OF GUILTY PLEASURES, INCLUDING KING KONG, FRANKENSTEIN, LAUREL AND HARDY, AND THE MARX BROTHERS. SHE ALSO HAD A WEAKNESS FOR MALTED MILK, PROCESSED CHEESE, AND APPLESAUCE.

*T*en years before her death, Frida's health began to fail considerably. Constant pain, alcohol, painkillers, corrective corsets, and surgeries became common, and she turned to journaling as a way to cope. Watercolors, text entries, sketches, poems, personal letters, color swatches, and even small paintings became what are now considered intriguing insights into her mind.

One of Frida's many letters inside a hidden trunk discovered at La Casa Azul in 2004.

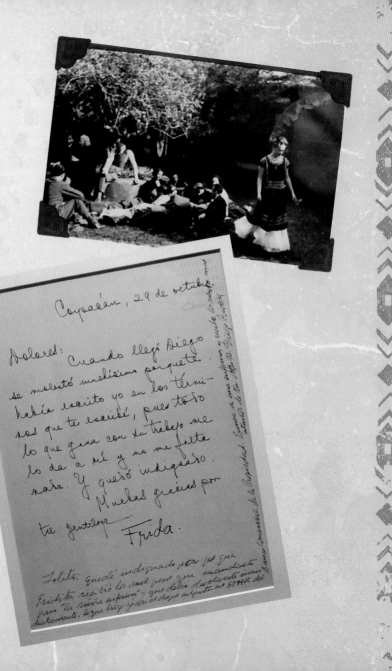

Coyoacán, 29 de octubre

Dolores:

Cuando llegó Diego se molestó muchísimo porque había escrito yo en los términos que te escribí, pues todo lo que gana con su trabajo me lo da a mí y no me falta nada. Y quedó indignado.

Muchas gracias por tu gentileza

Frida.

Somos a una enferma y cuida lo mío y cuido de tu hijo. B. Diego Rivera.

Lolita: Quedé indignado por ya que Frudita recibió los azul pero que necesita para "la niña enferma" y que debe devolverle inmediatamente. la que Diego todo el Diego en Coyoacán no 65472 del Reina Gonzalez de la Propiedad.

*T*HE CORE OF FRIDA'S PAIN CAME FROM HER CROOKED SPINE AND CONTINUED WITH THE INJURIES SHE SUSTAINED IN THE TROLLEY ACCIDENT AND HER SUBSEQUENT SURGERIES. AS A RESULT, SHE ENDURED MONTHS IN TRACTION WITH SANDBAGS TIED TO HER FEET, SOMETIMES SUSPENDED BY METAL RINGS. AT TIMES, FRIDA'S SURGICAL WOUNDS BECAME INFECTED UNDER HER CAST AND RELEASED A FOUL ODOR. IN 1946 SHE PAINTED *THE WOUNDED DEER* TO REPRESENT HER SENSE OF HOPELESSNESS. FRIDA'S HEAD IS ATTACHED TO THE BODY OF A SMALL DEER PIERCED BY ARROWS. SHE STANDS AMONG DEAD TREES WITH THE BLUE SKY FAR IN THE BACKGROUND.

"At the end of the day, we can endure much more than we think we can."

While the Riveras lived in the United States, they commissioned good friend, architect, and artist Juan O'Gorman to design their dream house and studio space and have it be ready upon their return home to Mexico City. Nestled on a corner in the traditional colonia of San Ángel, it consisted of two tall dwellings: a large red building for Diego and a smaller blue one for Frida. Between the rooftops sat a connecting bridge meant to represent the love between the couple. A cactus fence still surrounds the property. The construction sparked heated conversation in the community due to its merging of Mexican traditionalism and contemporary minimalism. In the five years Frida lived there (except for the brief time she lived in a separate apartment) she created multiple works, including two of her most powerful paintings: *What the Water Gave Me* and *The Two Fridas.*

Frida in her studio in San Ángel, Mexico City, 1945.

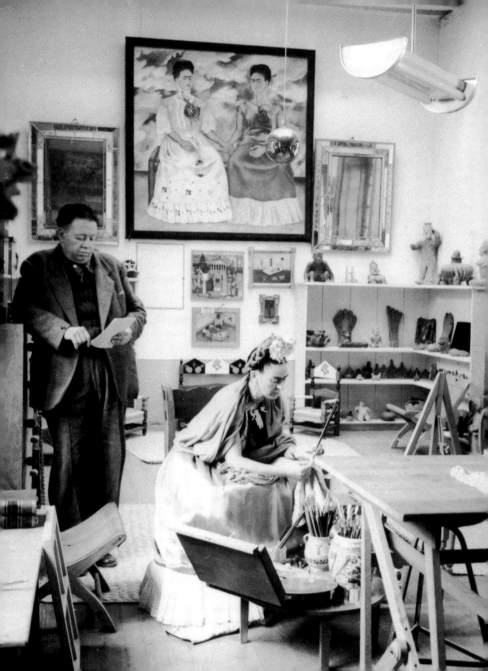

\mathcal{F}RIDA PRODUCED PAINTINGS EVERY YEAR FROM 1924 TO 1954, EXCEPT FOR 1934. THAT YEAR WORE HER DOWN PHYSICALLY AND MENTALLY. SHE WAS HOSPITALIZED FOR AN APPENDECTOMY AND UNDERWENT FOOT SURGERY, WHERE SEVERAL OF HER TOES WERE AMPUTATED. SHE ALSO LOST HER THIRD BABY AND THEN DISCOVERED DIEGO AND HER SISTER, CRISTINA, WERE CARRYING ON AN AFFAIR. THE RIVERAS SEPARATED, AND ONCE SHE HEALED, FRIDA MOVED OUT OF THEIR HOUSE IN SAN ÁNGEL AND RENTED HER OWN APARTMENT IN MEXICO CITY.

Frida in front of *A Few Small Nips (Passionately in Love)*, 1935.

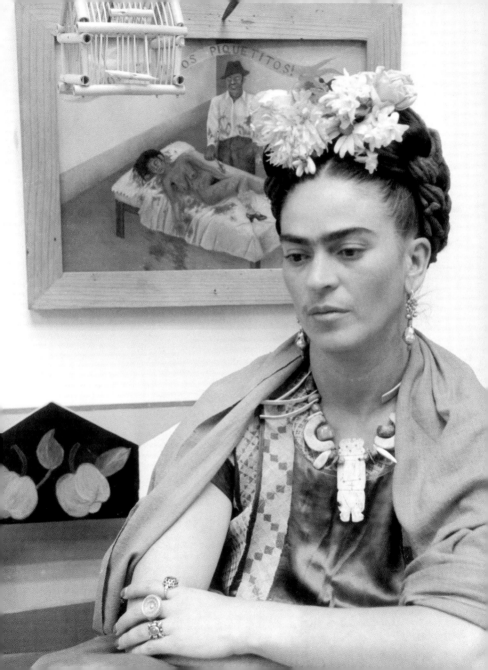

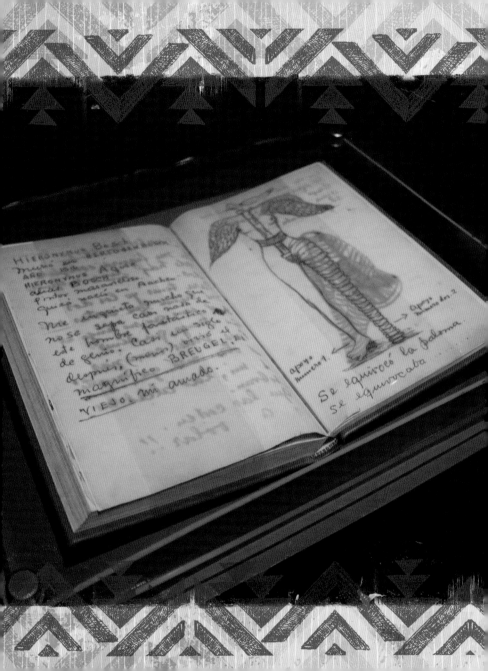

HIERONYMUS Bosch
muro de Rotterdam
ARE 1450 AGUEL
HIERONYMUS BOSCH
abril Pintor maravillos
Pintor nació en Aachen
que vivió en Aachen
Me atrapaste puedo ser
no se supo can nada de
este hombre fantástico
de genio. Casi un siglo
después, (menos) vivió el
magnífico BREUGEL mi
VIEJO, mi amado.

apoyo
Número 1

apoyo
Número dos 2

Se equivocó la paloma
Se equivocaba

Aside from her oil paintings, Frida designed many other art pieces. She carved the shape of her lips into a sawed-off table leg, constructed small puppets, embroidered, painted dishes, journaled in her diary, strung beaded necklaces, and, likely because of her father, took many photographs.

A spread from one of Frida's journals.

*A*FTER ENDURING ANOTHER SPINE OPERATION BECAUSE HER PREVIOUS DOCTOR FUSED TOGETHER THE WRONG VERTEBRAE, FRIDA SPENT AN ENTIRE YEAR IN THE HOSPITAL. HER SPIRITS LIFTED WHEN HER FRIENDS SNUCK IN BOTTLES OF TEQUILA, PAINTS, CANVAS, AND EVEN A FILM PROJECTOR SO SHE COULD WATCH MOVIES. PATIENTS FROM OTHER ROOMS WERE INVITED TO JOIN IN ON THE FUN.

"I tried to drown my sorrows, but the bastards learned how to swim, and now I am overwhelmed by this decent and good feeling."

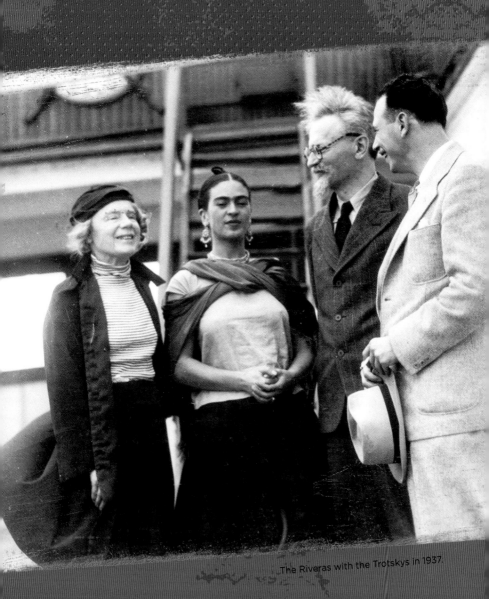

The Riveras with the Trotskys in 1937.

One of Frida's most controversial affairs involved Russian revolutionary Leon Trotsky. In 1937, Diego, a devout follower of Trotsky's brand of communism, invited Trotsky and his wife to stay at La Casa Azul after they were cast out of the Soviet Union. Shortly after arriving, Trotsky and Frida began a secret romance. Because of his beard, she called him her "piochitas" (little goatee), and he in turn wrote her love letters, which he hid inside books he passed on to her. Within months, Frida tired of him and broke off the relationship. She did, however, gift him a painting, *Self-Portrait Dedicated to Leon Trotsky (Between the Curtains)*. After two years and many disagreements with Diego, Trotsky and his wife moved to their own apartment in Mexico City. Months later, Trotsky was assassinated.

Throughout her lifetime, Frida wore more than twenty-eight different corrective corsets to help straighten her spine. The materials the corsets were made of ranged from leather to steel to plaster, depending on what exactly needed correcting on her spine. Frida painted on some of the corsets as she wore them, lying in her bed. She even created the piece, *The Broken Column*, a self-portrait that shows her tearfully dealing with the pain, yet still appearing strong and determined.

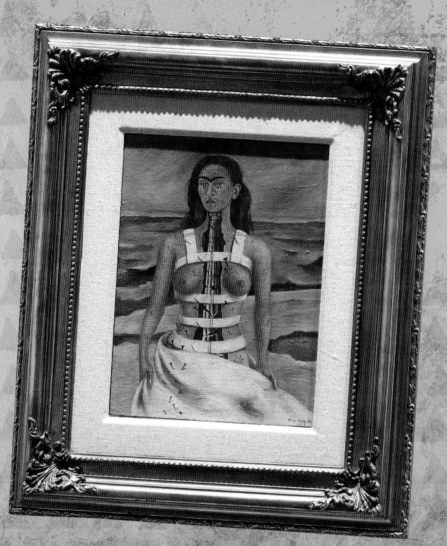

The Broken Column, 1944.

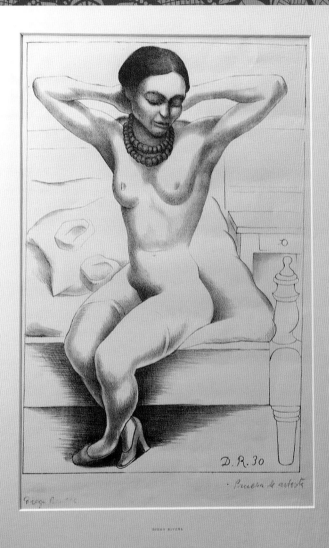

Nude with Beads (Frida Kahlo) by Diego Rivera, 1930.

"Can one invent verbs? I want to tell you one: I sky you, so my wings extend so large to love you without measure."

*F*rida's visual renditions of conception, pregnancy, miscarriage, abortion, body image, love, and gender roles were all considered groundbreaking for the time. Diego described them in his autobiography as "paintings which exalted the feminine qualities of endurance of truth, reality, cruelty, and suffering. Never before had a woman put such agonized poetry on canvas..."

Frida at work on *Self-Portrait as a Tehuana (Diego on My Mind)*, 1943.

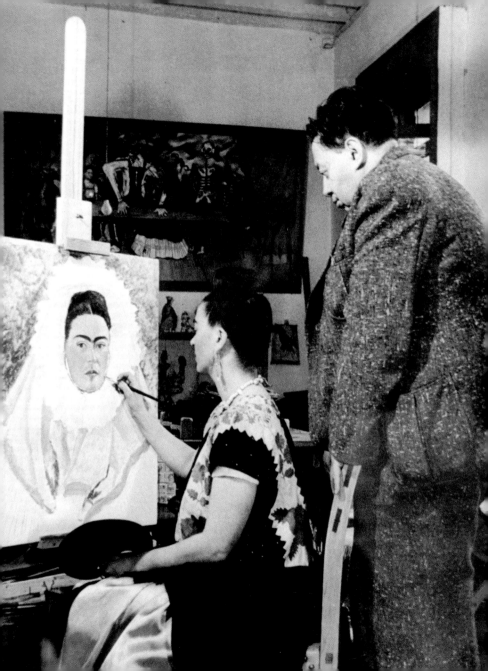

MANY OF FRIDA'S PIECES REVOLVED AROUND THE POLITICS OF HER PERSONAL AGONY AND FEMININITY, BUT SHE ALSO CREATED SEVERAL PAINTINGS THAT DEALT DIRECTLY WITH WORLD POLITICS. *SELF-PORTRAIT ON THE BORDERLINE BETWEEN MEXICO AND THE UNITED STATES, MY DRESS HANGS THERE, MARXISM WILL GIVE HEALTH TO THE SICK,* AND *SELF-PORTRAIT WITH STALIN* ARE AMONG THEM. SHE EVEN APPEARED IN ONE OF DIEGO'S POLITICAL MURALS, *THE ARSENAL.*

"I must fight with all my strength so that the little positive things that my health allows me to do might be pointed toward helping the revolution. The only real reason for living."

*I*t's rare to ever see a photo of Frida with an open smile. She hated her crooked teeth and hid them by closing her lips, especially for photographs. Even when she laughed, she often used her hand to cover her mouth.

Frida paints *Portrait of Mrs. Jean Wright*, 1931.

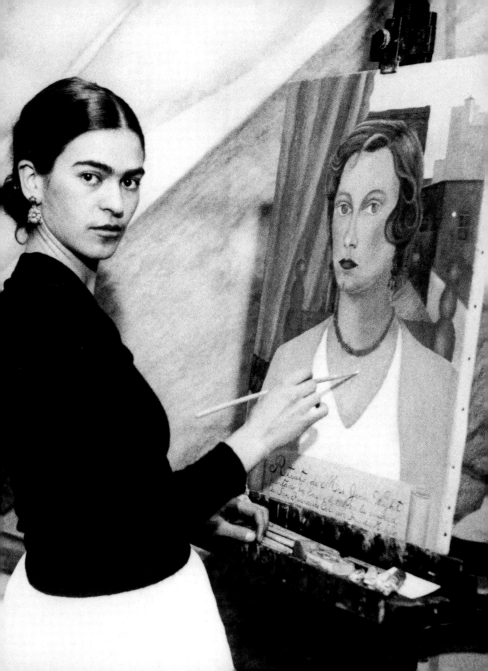

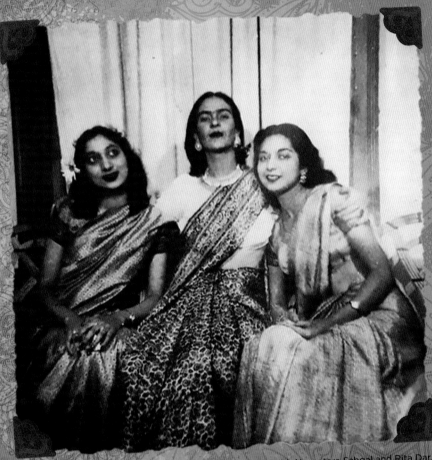

Frida with Nayantara Sahgal and Rita Dar.

*G*uests from across the globe visited La Casa Azul during Frida's time, including the daughters of Vijaya Lakshmi Pandit, India's first ambassador to the Soviet Union, United States, and Mexico. Sisters Nayantara Sahgal and Rita Dar had just graduated from college and traveled to Mexico. They met Frida through a friend and exchanged gifts with her. They dressed her in a colorful sari and Frida offered them signed photos.

𝓕RIDA NEVER COMPROMISED HER WILL TO LIVE LIFE TO ITS FULLEST. EVEN IN HER FINAL YEARS, BEDRIDDEN OR IN A WHEELCHAIR, SHE FORGED AHEAD. SHE ATTENDED HER FIRST EVER SOLO EXHIBIT IN MEXICO CITY...IN HER BED. SHE ORDERED IT TRANSPORTED TO THE GALLERY AHEAD OF TIME AND THEN TRAVELED TO THE GALLERY BY AMBULANCE. IT TOOK FOUR MEN TO CARRY HER FROM THE VEHICLE AND PLACE HER IN HER BED, WHERE SHE JOYOUSLY CELEBRATED THE EVENT WITH HER FAMILY AND FRIENDS.

"It is not worthwhile to leave this world without having had a little fun in life."

*I*n the last years of Frida's life, she
continued to paint and journal; however,
her painkillers and fragile state took
their toll on her art, as noticed in
Congress of Peoples for Peace (1952) and
Self-Portrait in a Landscape with the
Sun Going Down (1954). Even though
her work lacked the delicate details and
precision she had become known for,
she didn't let it stop her from creating.

"Painting completed my life."

"I wish I could do whatever I liked behind the curtain of 'madness.' Then: I'd paint; pain, love and tenderness, I would laugh as much as I feel like at the stupidity of others, and they would all say: 'Poor thing, she's crazy!' (Above all I would laugh at my own stupidity.) I would build my world which while I lived, would be in agreement with all the worlds. The day, or the hour, or the minute that I lived would be mine and everyone else's—my madness would not be an escape from 'reality.'"

When Frida knew her last days were near, she had her bed moved to the corridor in La Casa Azul. She could hear the wind, see the plants and animals, and absorb all she could from life through the window.

Witnesses recall that during the last moments before Frida's corpse entered the crematorium, the heat was so intense that it forced her body into an upright sitting position. Her long ebony hair blew up and around her head, and her face appeared to be smiling.

"My blood is a miracle that, from my veins, crosses the air in my heart into yours."

Dia de los Muertos ofrenda in honor of Frida at La Casa Azul.

IN FRIDA'S LAST YEAR OF LIFE, SHE LEFT BEHIND TWO ICONIC STATEMENTS THAT SEEMED TO SUM UP ALL THAT WAS HER LIFE. FIRST WAS *VIVA LA VIDA*, HER LAST PAINTING, COMPLETED EIGHT DAYS BEFORE SHE DIED. THE WORK CONSISTS OF WATERMELONS SHOWN FROM VARIOUS ANGLES AND CUTS. THE FRONT SLICE READS "VIVA LA VIDA (LONG LIVE LIFE), FRIDA KAHLO, COYOACÁN 1954 MEXICO." THEN THERE WAS FRIDA'S FINAL WRITTEN DIARY ENTRY FROM JULY 1954:

Frida Kahlo

"Espero alegre la salida y espero no volver jamás."

"I hope the exit is happy and I hope never to return."

Resources

Books

Alcantara, Isabel and Egnolff, Sandra (2011), *Frida Kahlo and Diego Rivera*, Prestel Publishing

Colle, Marie-Pierre and Rivera, Guadalupe (1994), *Frida's Fiestas: Recipes and Reminiscences of Life with Frida Kahlo*, Clarkson Potter

Fuentes, Carlos (2005), *The Diary of Frida Kahlo: An Intimate Self-Portrait*, Abrams

Grant, Hardie (2018), *Pocket Frida Kahlo Wisdom: Inspirational Quotes and Wise Words from a Legendary Icon*, Hardie Grant

Herrera, Hayden (1998), *Frida: A Biography of Frida Kahlo*, Bloomsbury Publishing

Kahlo, Isolda P. (2004), *Intimate Frida: Frida Kahlo, 1907–1954*, Dipon

Prignitz-Poda, Helga (2017), *Hidden Frida Kahlo: Lost, Destroyed or Little-Known Works*, Prestel Publishing

Taymor, Julie and Hayek, Salma (2002), *Frida: Bringing Frida Kahlo's Life and Art to Film*, Newmarket Press

Vinci, Vanna (2017), *Frida Kahlo: The Story of Her Life*, Prestel Publishing

Wilcox, Claire and Henestrosa, Circe (2018), *Frida Kahlo: Making Her Self Up*, Victoria & Albert Museum

Website Resources

https://artsandculture.google.com/entity/m015k04

https://fridakahlocorporation.com

www.fridakahlo.org

www.moma.org/artists/2963

www.pbs.org/weta/fridakahlo/

Other

Joyería MATL
Jewelry store from the family of Matilde Poulat.

San Jacinto Plaza
Mexico City, Mexico

Heard Museum
Museum host of the shows *Frida Kahlo and Diego Rivera* and *Frida Kahlo, Her Photos.*

2301 N. Central Avenue
Phoenix, Arizona 85004
https://heard.org